A Song of Lilith

A Song of Lilith

Poem by Joy Kogawa

Artwork by Lilian Broca

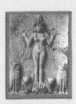

POLESTAR

Polestar Book Publishers and Raincoast Books acknowledge the ongoing support of The Canada Council; the British Columbia Ministry of Small Business, Tourism and Culture through the BC Arts Council; and the Government of Canada through the Book Publishing Industry Development Program (BPIDP).

Cover image by Lilian Broca.
Cover and interior design by Gabriele Chaykowski.
Printed and bound in Canada.

Canadian Cataloguing in Publication Data

Kogawa, Joy.
 A song of Lilith

 ISBN 1-55192-366-1

 1. Lilith (Semitic mythology)—Poetry. I. Broca, Lilian, 1946- II. Title.
PS8521.O44S62 2000 C811'.54 C00-910716-9
PR9199.3.K63S66 2000

Polestar Book Publishers
An imprint of Raincoast Books
9050 Shaughnessy Street
Vancouver, BC
V6P 6E5

54321

For my husband, David Goodman,
and our sons, Mark and Eric Goodman.
— Lilian Broca

For my grandchildren,
Matthew David Haruo Canute and Anne Nozomi Canute.
— Joy Kogawa

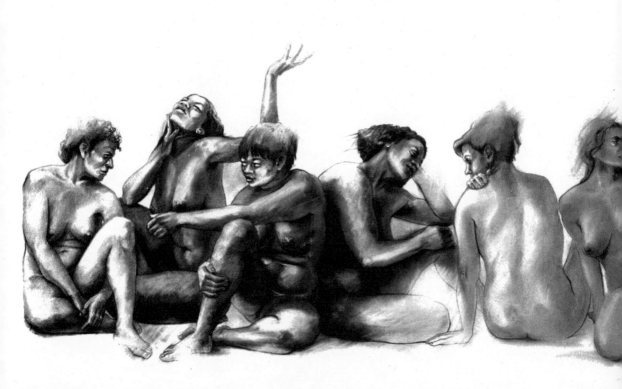

Contents

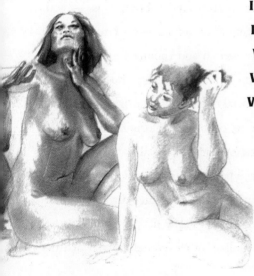

Artist's Preface

This book began in a modest way. In 1995, I began a series of artworks on the legendary Lilith, a figure I had come across two years earlier while doing research for an exhibition on goddesses. After I had a dozen or so finished pieces, I began seriously thinking about a publication — a "text and art collaboration."

As I began making images of Lilith, her mystery and subtlety was — and continues to be — a revelation for me. In preparing to create the works I experienced periods of gestation during which I would do research and ruminate on ideas. My primary focus was on Lilith as a symbol for the human condition. Because Lilith crosses historical, gender, ethnic, religious and social boundaries, I portray her mostly in the nude (clothes tend to date and point to countries of origin) and mostly outdoors among rocks, water, sky and earth (interiors indicate social status, periods in history and civilizations). Choosing the body type for Lilith was somewhat of a challenge. After considering the message of Lilith and her resonance through time, I felt it was appropriate to use a more contemporary (physically fit) prototype for the exquisitely beautiful woman. My Lilith — unlike other contemporary artistic

renditions of her image, which portray an ethereal, delicate, semi-transparent sky-bound figure who melts into the background — is a solid, powerfully down-to-earth woman with a great sense of justice and integrity. Lilith is not a Mother Goddess; she is not the archetype for the loyal, nurturing, family-oriented woman. Instead, Lilith is the archetype for the intelligent, independent, spiritual, decisive woman of action with sensitivity to the need for change in the world. The legends tell of Lilith's extraordinary beauty. After carefully examining my choices of body type I chose the beauty ideal of today — the physically fit woman.

The artworks consist of acrylic paintings, graphite drawings, a combination of the two media, and stone lithography in colour and in black and white. I have created (through numerous experiments) a textured background which, when manipulated in certain ways, acquires an ancient appearance. The material I use for this purpose is spackle on panel or on paper. When dry, spackle can be sanded, tinted, drawn on and sanded again until the desired effect is reached. I felt the most potent way to depict the high drama of these narrative artworks was through sharp contrasts in lights and darks. This, plus the prominent use of black graphite on a white surface, gives the subject matter a dynamic sense of power as well as a spiritual sensibility.

It was in the summer of 1998 that two of my best and oldest friends, Kristine Bogyo and her husband Anton Kuerti (both classical music performers) came to visit my husband and me in Vancouver. In my studio, they came up with the idea of a concert/performance that would include narrated text, artworks and music

specifically composed for Lilith. We were all very excited and Kristine began the search for writer, composer, actor and performers. We had only the artworks and the legend to our name, but still there was an immediate overwhelming response. The results of Kristine's dedicated search brought Joy Kogawa as the writer, Larysa Kuzmenko for composition, Moira Wylie for narration and a quintet of performers.

Not long thereafter, Joy and I agreed to collaborate on a publication. It was instant magic. At that point I began to follow Joy's departure from the legend and to create additional images using my distilled vision of her magnificent words. Through daily e-mails, we were able to keep our collaboration smooth and steady. This manner of working together was a first for both Joy and myself; I can safely say that it has enriched us both.

Invaluable help came from all the "Liliths and Adams" who modelled for me, Nancy Gabor, Camrose Ducote, Cam Mathewson, Peter Reid, Heidi Gremaud and Odessa Shuquaya. Also from friends who supported this project all along — Linda Coe and Letia Richardson, Kristine Bogyo and Anton Kuerti.

I am grateful to all.

— Lilian Broca, August 2000

X

Author's Preface

I don't remember the exact day that Kristine Bogyo called, asking if I would consider writing a narrative on the subject of Lilith. But I do remember that I was charging along at full speed in the day and night labour of the Toronto Dollar, a community currency, and was turning down every request to write anything at all.

"Lilith?" I knew almost nothing about her.

"Yes. It's for a multi-media performance." Kristine's voice was characteristically bubbly and enthusiastic.

My strong inclination was to say no. But I was indebted to Kristine and her husband, Anton Kuerti. They had performed, at my request, for the first benefit concert of the Toronto Dollar. I told Kristine I would think about it.

Within days I was deluged with art work from the prolific soul of Lilian Broca. Rich, powerful images. Along with the art, she sent an outline of her research on Lilith.

According to legend, as I now understood it, Adam's first wife Lilith was born, like him, of dust. When Adam sought to dominate her, she became distressed, uttered the unutterable and ineffable name of God, sprouted wings and flew away to the ends

of the earth — the Red Sea. Adam, bereft, asked God for her return, and three angel emissaries were sent to fetch her. She refused to return and was transformed into a demon.

It was during this time — while I was still "thinking about it" — that the poem arrived in my sleep, virtually complete, on the wings of a month of midnights.

There are, as I see it, connections between my daytime community work and the pen's night wanderings. Both entailed a sideways glance away from Mammon's demonic and mesmerizing frontal glare. For me, the puzzling injunction to "turn the other cheek" when struck meant that one was to rigorously and vigorously look away from the face of the enemy. During the day, the Toronto Dollar was an exercise in shifting the mind away from wailing about economic disparities and focusing instead on action and the power of connection within the community sector. I was beginning to learn how Ruah, the wind of God, blows most clearly through the corridors of the open heart. At night, Lilith too was turning her mind. From within the locus of her distress, at the place of utmost emptiness, she was discovering the secret of Love's design for human loss. It was as she turned aside from the focus of her suffering that she heard the Great Surprise. That was precisely the moment of blessedness, the moment of recognition and wings. She leapt. She fell out of the grip of despair and into Love's embrace.

My collaboration with Lilian Broca has been good — light-handed and undemanding, rather gentle yet full of eagerness, and with the deference that arises from mutual

respect. Most of all, we have both felt alive with Lilith and with all the other daughters of Lilith who have been wondrously drawn together for this birthing.

To all the creators and performers for the concert we should add the crew at Polestar — Emiko Morita, Michelle Benjamin and particularly Lynn Henry, who has "the eyes to see, the ears to hear" and guided the book through the rapids to its completion.

— Joy Kogawa, August 2000

The Lilith Legend

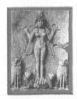

In her fascinating article "The Lilith Question" (*Lilith Magazine*, 1976), eminent feminist writer Aviva Cantor poses the question: "Who is Lilith? Or more to the point, who is the real Lilith — the beautiful rebel against tyranny or the wild-haired vengeful witch?"[1] Cantor goes on to ask: Is she a myth without historical basis or does she embody a clue to our past? A study of Genesis shows that the Bible has two distinct stories of creation: "God created man in His own image, male and female created He them. God blessed them and said to them, 'Be fruitful and increase in number; fill the earth and subdue it.'" (Genesis 1:27, 28). A new and different version is told in Genesis 2: 18-25, in which God decides to make a helper "suitable for Adam," puts Adam to sleep, and fashions Eve out of one of Adam's ribs. Adam's first words upon seeing Eve are of relief; he says: "…at last bone of my bones and flesh of my flesh; she shall be called 'woman,' for she was taken out of man." (Genesis 2:23, as translated by Raphael Patai).

Cantor goes on to ask: "Why 'a suitable helper'? Why 'At last bone of my bones…'? Could Eve be the 'improvement' over Lilith, the woman who proved to be

too assertive? By using Adam's flesh and bone, could God have ensured Eve's total devotion to Adam? Did Eve serve as the antidote to Lilith's short-lived attempt at egalitarianism?"

According to Cantor, we learn from later manuscripts that Lilith felt herself to be Adam's equal ("We are both from the earth." Ben Sira 23 a-b) but Adam refused to accept her equality. Eventually, the frustrated Lilith used her wisdom, uttered God's secret name, grew wings and flew away from Adam and the Garden of Eden. At Adam's urging, God dispatched three angels to negotiate her return. When these angels made threats against Lilith's descendants, she countered by vowing to prey eternally upon newborn human babies, who could be saved only by invoking the protection of the three angels. In the end, Lilith stood her ground and never returned to her husband. Adam was provided with a new mate, Eve, who was fashioned out of his rib, but he and Eve fell from God's favour shortly after. In Jewish tradition, Lilith after her escape from Adam is a demon: "...The wild creatures of the desert shall meet with the jackals, the goat-demon shall cry to his fellow, the Lilith shall also repose there, and find for herself a place of rest..." (Isaiah 34:14, as translated by Judy Weinberg). This reputation is embellished with legend upon legend of Lilith's vengeful activities to harm the children of women who give birth without strong amulets to ward her off.

"The Lilith story may be a clue to our own history..."[2] suggests Cantor. She

goes on to posit that Lilith may represent a whole group, a whole generation, of women. Or she may reflect the existence of a type of woman who appeared in generation after generation — a woman who would not be dominated, a woman who demanded equality with man. "Or she may embody the thoughts and feelings of women about their equality, even if they could not act on them in their generation."[3] With so little solid material about women of the ancient past, particularly of Lilith's nature, "it would be unthinkable for us to let Lilith be forgotten simply because of male biases grafted onto the story of her revolt."[4]

Aviva Cantor explains that from the beginning Lilith perceived herself as equal to Adam — equal, therefore, to man.

"Her consciousness of equality was not only high, it was a given, a natural process."[5] Anything less was unthinkable, unnatural. Aside from recognizing tyranny for what it was, Lilith resisted it as well. She did not appeal to God to straighten out her relationship with Adam; instead, Lilith took the ultimate risk in order to retain her dignity. By leaving Adam, Lilith proved herself to be "courageous and decisive, willing to accept the consequences of her action."[6] For the sake of freedom and independence, Lilith was "prepared to forsake the economic security of the Garden of Eden and to accept loneliness and exclusion from society."[7]

Cantor and others have made the argument that Lilith was a powerful female — probably the world's first feminist. She radiated strength and assertiveness. She refused to cooperate in her own victimization. The ancient Rabbis, who made the

ultimate decisions about which stories were to be set in the canon and which were to be omitted, realized that this Lilith could be easily regarded as a role model for women. Her condition provoked too much anxiety in the men to allow such behaviour to be encouraged. Hence, the elimination of the Lilith legend from the canon. Against all odds, the story of Lilith survived for two thousand years or more. The legend had been altered, however: in time, Lilith was accused of seducing men with her unimaginable beauty, and male nocturnal emissions caused by erotic dreams were attributed to Lilith's visitations. Crib deaths were attributed to Lilith's thirst for the murder of newborn babes, and pregnant women wore amulets against Lilith's evil designs. This revengeful and demonic aspect of Lilith eventually overshadowed the original independent and intelligent character, influencing, reflecting and shaping men's feelings towards assertive women for centuries thereafter. Women who had the potential to become strong-willed and assertive were warned that they would become Lilith-like demons, witches, whores and murderers of children.

Lilith scholar Judy Weinberg observes that, when stripped of the overlay of medieval mysticism and demonology, this Lilith emerges as an independent spirit.[8] Lilith's refusal to be subservient ("I will not lie beneath you", Ben Sira 23a-b) and escape from Adam make it clear that, had she succeeded in her battle for equal rights, today she might "represent that spark of original creativity in whose image women could retrace and recreate their history."[9] Aviva Cantor emphasizes the fact that legends of Lilith-as-demon, the vengeful female witch, are not unique to Jewish

culture and tradition. Many scholars theorize that vengeful female deities or demons, like the Greek "empusae," represent the vestiges of the dying matriarchy or are an attempt by men to discredit the matriarchy. Elizabeth Janeway, in her pioneering study *Man's World, Woman's Place*, "points out that every positive role has a negative flip side, a 'shadow role'."[10] Negative roles support the patriarchal order just as positive ones do; the negative ones are threats, the positive ones are promises. The Lilith of demonic legend is a negative, shadow role — the flip side of Eve, who represents the enabler or the altruist.

In *A Song of Lilith*, the figure of Lilith represents the complementary half of Eve — the assertive, courageous and independent part. She is a modern embodiment of an ancient symbol — the woman created equal, who can help us to become whole by reconciling traditionally masculine and feminine traits. She is a woman of power, compassion, justice, healing and vision — a guide into the future for all of us.

Footnotes:

1. "The Lilith Question", Aviva Cantor, *Lilith Magazine*, p. 1

2. Ibid p.2

3. Ibid p. 2

4. Ibid p. 2

5. Ibid, p. 1

6. Ibid p. 1

7. Ibid p. 1

8. "Lilith Sources", Judy Weinberg, p.1

9. Ibid p. 1

10. Ibid p. 2

Sources:

1. "The Lilith Question", by Aviva Cantor, *Lilith Magazine*, (New York, NY, 1976).

2. "Lilith Sources", by Judy Weinberg, *Lilith Magazine*, (New York, NY, 1976).

3. *The Hebrew Goddess*, by Raphael Patai (Wayne State University Press, Detroit, 1990).

4. *The Book of Lilith*, by Barbara Black Koltuv, Ph.D. (York Beach, Maine: Nicholas - Hays Inc., 1976).

5. *The Coming of Lilith: Toward a Feminist Theology*, by Judith Plaskow, ed. Judith Plaskow and Carol Christ (New York: Harper and Row, 1979).

6. *Man's World Woman's Place*, by Elizabeth Janeway (New York, Delta: 1972)

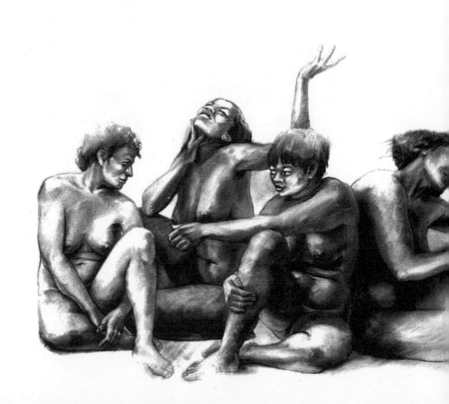

I

The First Song

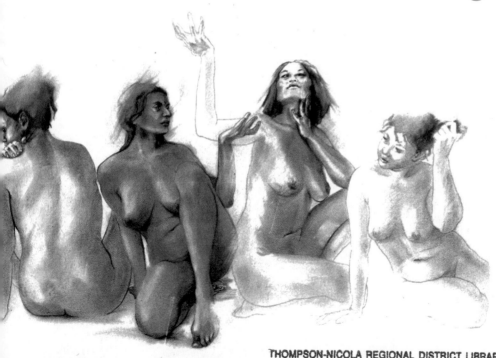

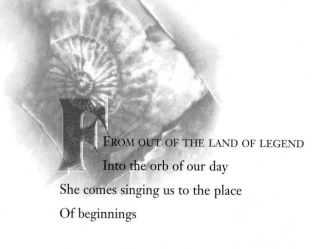

Ƒʀᴏᴍ ᴏᴜᴛ ᴏꜰ ᴛʜᴇ ʟᴀɴᴅ ᴏꜰ ʟᴇɢᴇɴᴅ
 Into the orb of our day
She comes singing us to the place
Of beginnings

The whispering sound of wind
Winds its way down the spiraling
Leaf-curling ways of the cochlea
Along the fine highwire fields
In our listening ear, she
Buds her way up through the bark
Of earth's story, her body
Wet as early dawn

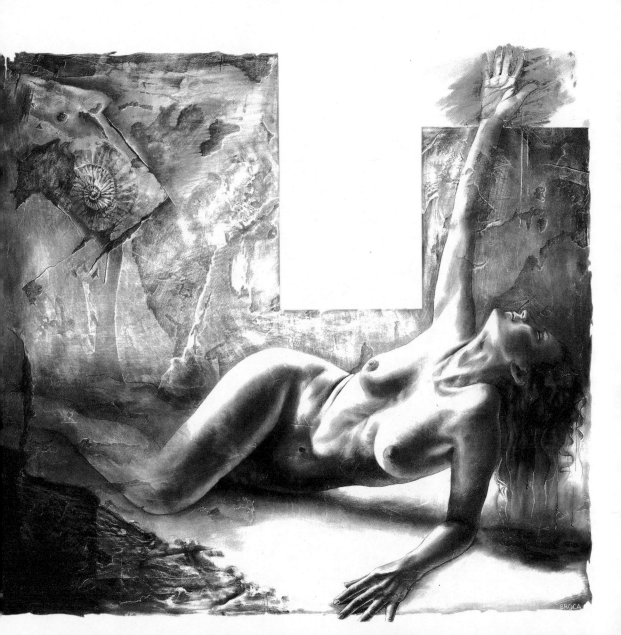

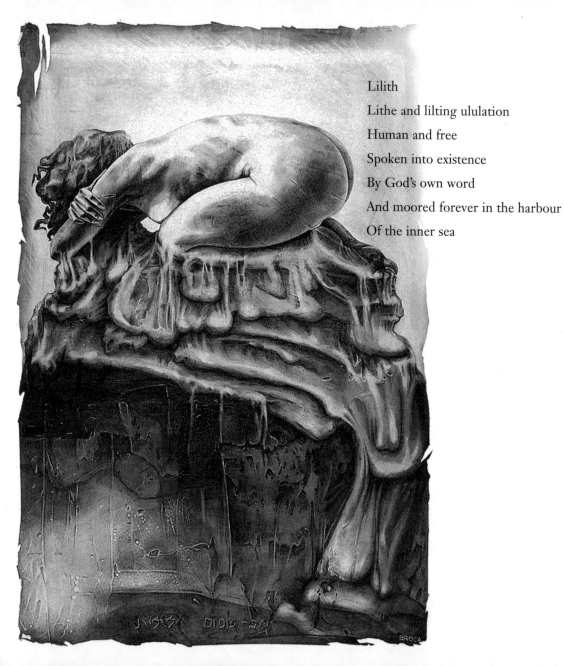

Lilith

Lithe and lilting ululation

Human and free

Spoken into existence

By God's own word

And moored forever in the harbour

Of the inner sea

Lilith

Earth's first and elemental woman
Made like man from dust
And fleshed in mortality
Not from woman born
Nor yet from man
But from earth's crust
From mist and deep fire
Molten rock drawn from the furnace
Of earth's volcanic womb —
Magma, heat and dream
And stone made animate,
Blood and bone
By God's own hand —
Grassy hair, chlorophyll, lichen,
Belly, shoulders, limbs
Fingertips, sunlight —
A creature born communing
In the hum of consciousness

The status of her birth is this:
Earth dweller
In the garden before gardens
In the time before time
In the beginning before later beginnings
Under starlight
In the realm of creaturehood, animal
And divined, like Adam,
By the touch of God

These two, these first
Not yet aware of mortality
Not yet fashioning myths
To fill the void
Not yet knowing
That they are pitiable
As the mewl of a drowning kitten
To be rescued by God's reaching hand

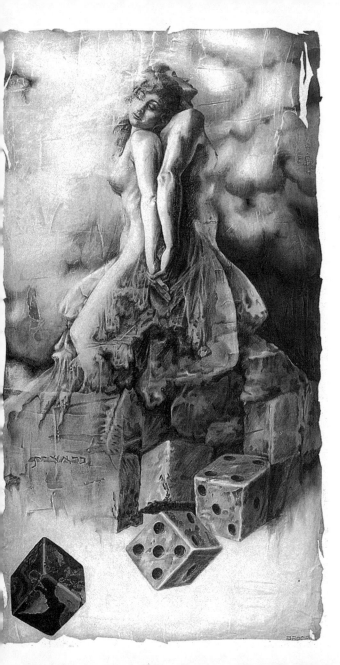

Adam and Lilith
Joined and made one
Lilith and Adam
Co-creators of an original bond,
Their encircling arms the womb
Where humanity is born

Up and down the spine of stars
They dance, dance
Unfettered and free,
Unencumbered by dread
Connected by the invisible umbilical,
The single cord that wraps
The universe in thought
They dance through waves
Of molecular memories
In the rhythm of clouds
Or ripples on the sea
Tide bound, moon bound
Linked by light and water
And the bright melody of limbs

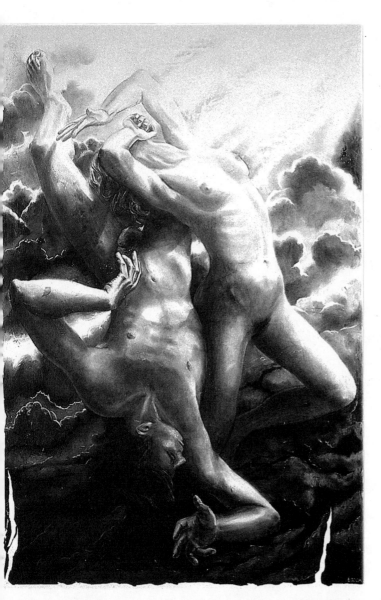

They are the first movement
And the first song
The first dancers
In the first dawn
Once danced
They dance forever
In the deep delight
Of their first
And truest love

Then into the idyll,
Into their bright bodies
Of sense and sensation
Of touch and tenderness,
Into their holy communion
Creeps the primal temptation
The tentative pleasure of the chase
And Adam veers aside
To the boundaries of springtime.
He lunges at his mate.

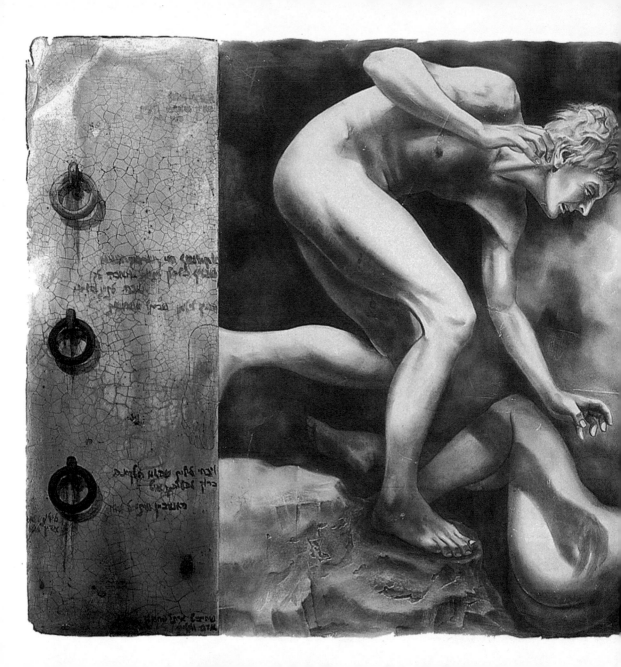

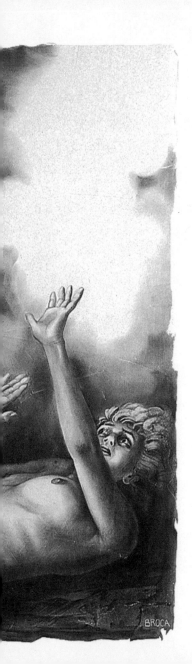

In that one action

The lion finds its prey

The hunter, the hunted;

The bond of equality severed

Is become the whip of domination.

Adam the man

Seizes the thunderclap

And the primordial and original sin

Is unleashed into the spiral

Of a new and dark design

Adam declares the end of the first dance

And the beginning of storm,

Raincloud and hail,

And he himself the Lord of Summer

An unruly ruler

In his world of new rules

This is the first and foremost folly
To which Adam succumbs,
The seduction that leads
To the land of bitter fruit
Of shards and appearances

Down the patriarchal path of separation
Blows the tempest
Howling with the energy of red dwarves
Darkness devouring light
Adam now hungering
For kingdoms, crowns, empires —
Adam harnessing the wind and waves
And all womankind —
Rides the wild horses
Of the will to conquer

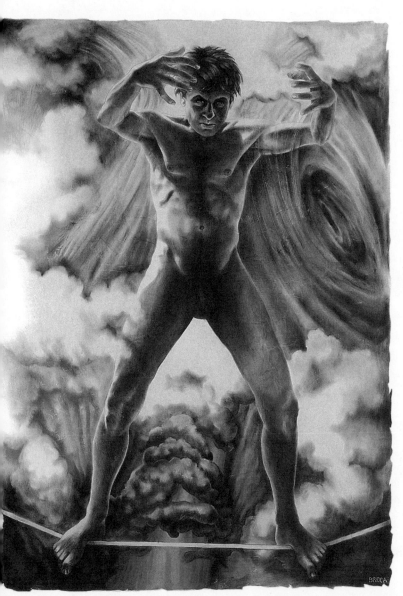

Unchastened man
Wanting more than enough
Is the first of earth's creatures
Tempted and tried
And fallen from grace —
The first to forget
That the dance
And not the dancer
Holds the power.

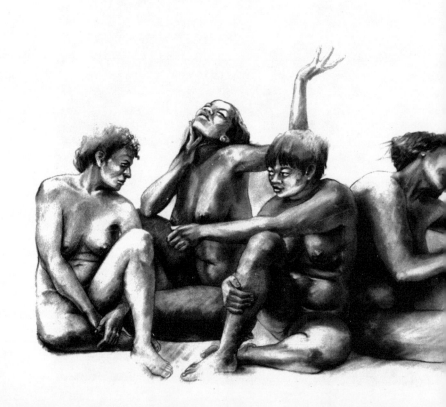

II

She Turns Her Mind

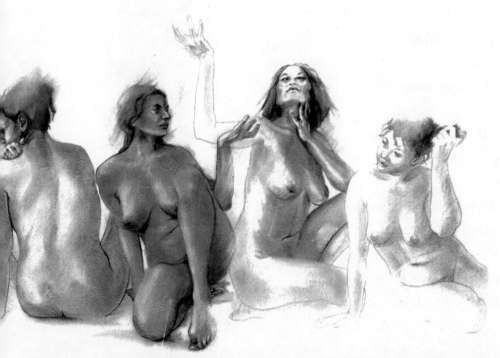

H

HOW HAS THIS ALL COME ABOUT?

This red-eyed staring out the window

Grey sky day of bewilderment

This overwhelming abandonment

And chaos of longing in which Lilith sits

Trapped in a crossfire of strange sounds

Gunfire and battle shouts

What is the way out?

There is no safety now:

Before the sun rises

Lilith wakens to treachery

And entrapment

She hadn't known it was going to be this way —

Sadder than sad,

More alone than she thought possible,

She finds herself in the darkness

Breathing the light

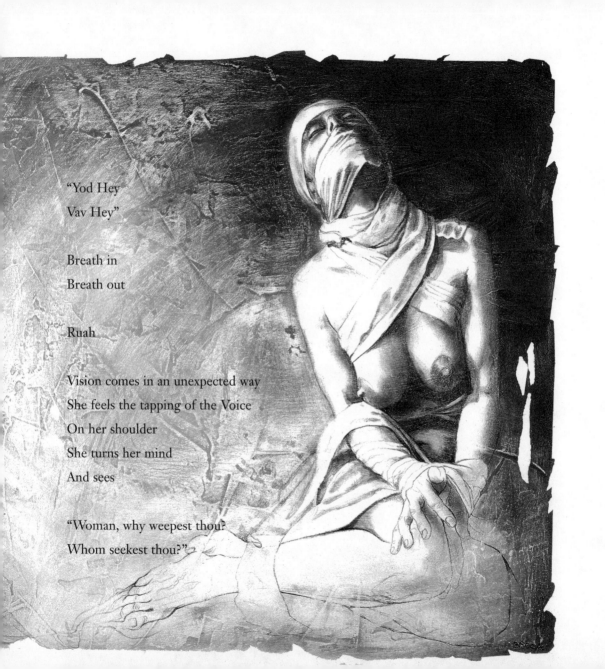

"Yod Hey
Vav Hey"

Breath in
Breath out

Ruah

Vision comes in an unexpected way
She feels the tapping of the Voice
On her shoulder
She turns her mind
And sees

"Woman, why weepest thou?
Whom seekest thou?"

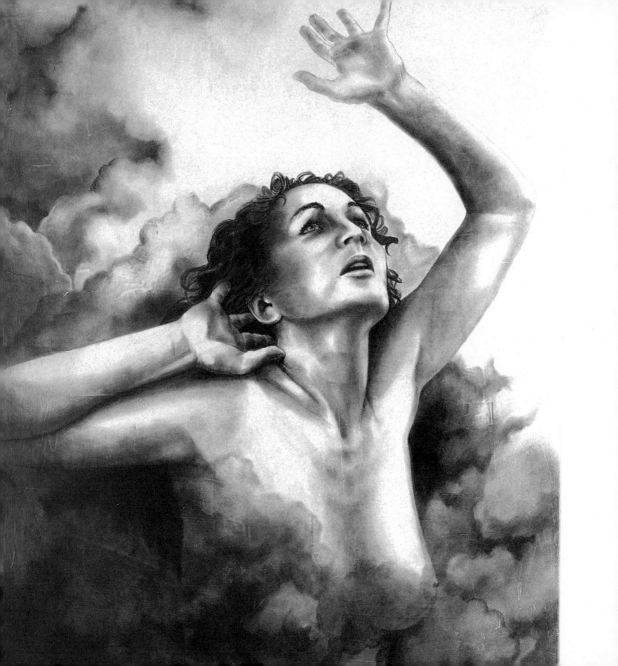

Headlong into the not-yet morning
She dives.
This is the hour
Where loss is transformed
By Love's design

Down through the generations
Of ice flows drifting
Continents forming
Dinosaurs roaming
Atlantis and empires
Sinking, fading, rising again
Down through the corridors of eternity
Comes the Voice and the Word
That which is spoken
And that which is heard
The same glad cry
Of surprise and joy

"El Shaddai
Rabboni
My Beloved"

Such are the utterances
That weave through the skies,
Filaments of sight
On the loom of the night

For the longing with which she longs
Is the longing that speaks through her
And recognition is as instant
As the sound of a name

"Lilith"

God who speaks in the whir of wheels
And the opening roar of daffodils
In the click of rain against each
Unseen window pane —
God who prays our prayers
In groans too deep for uttering —
Is the One who is with us
In the gardens of the world
Where Love lies entombed

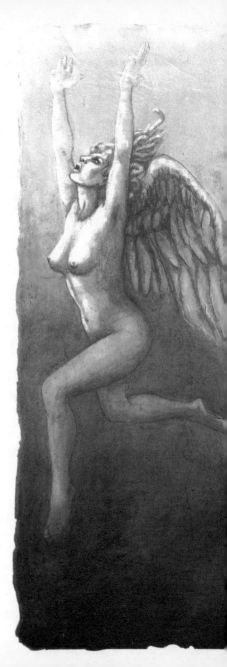

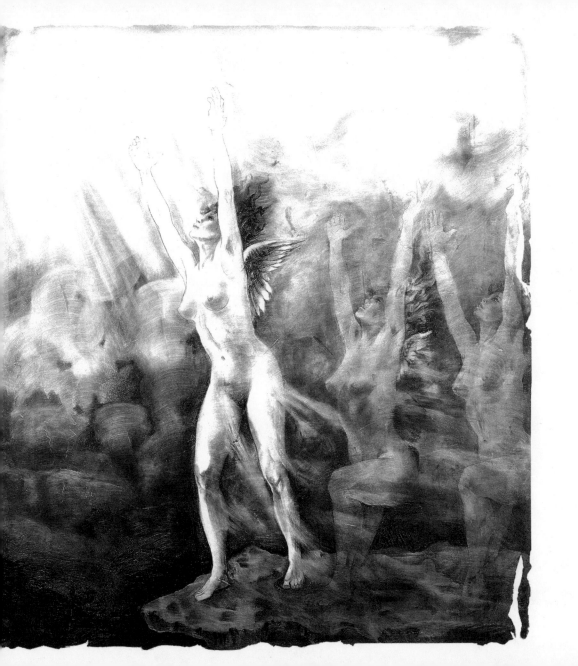

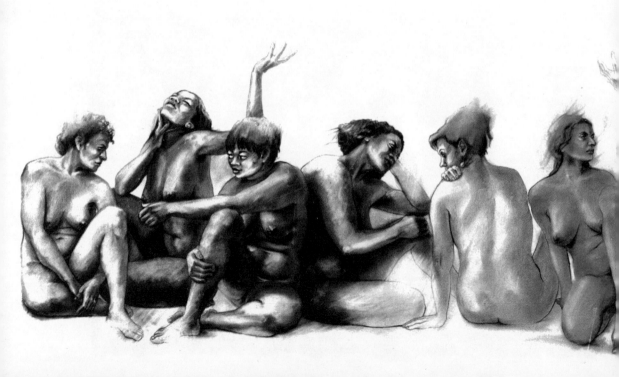

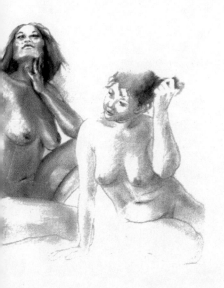

In the earliest hour of the earliest loss

At Lilith's own wall of tears

In the garden of her wailing

Is the Singer who is the Song

The Holy One who does no wrong

God's endlessness towards her

Is the action she reflects

God's leap of love

Her leap of trust

And woman of dust is thus reborn

As woman of air

Woman wind-formed

Woman in her flight

Granted wings

And healed henceforth of immobility

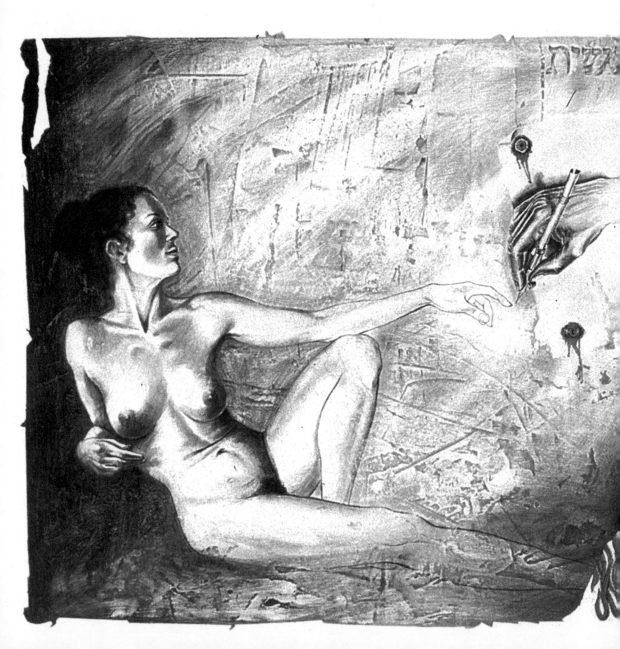

She is become the transport
Of speech and connectivity
Securing for all time
Our communion with the Holy —
Our mother tongue —
Relatedness —
These gifts bequeathed to humanity

Through Lilith, through Magdala
Through woman

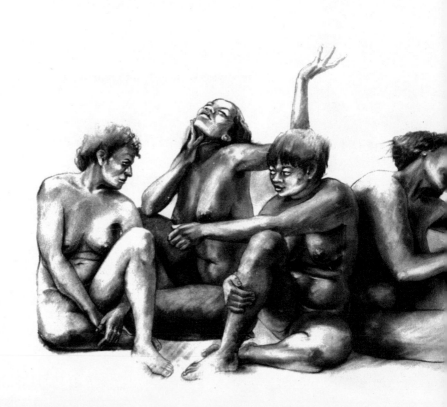

III

Her Wings and Wanderings

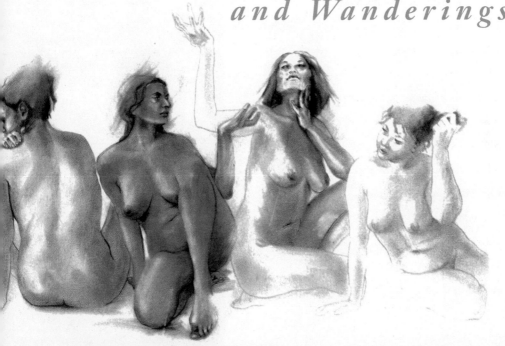

THIS IS HER TELLING —
Not mediated through history
Where she is locked in the turbulence
Of man's memory.
Her story is of her body, her blood
Her wings and wanderings
And her many new beginnings

The image changes
Blowing through time;
The colours deepen, brighten;
The canvas grows wide, wider.
She moves from clear water
Through tainted earth and fire
Onward as windy woman
Winged and wily wonder
Carrying within herself
Her God-given
Autonomy

Winged

28

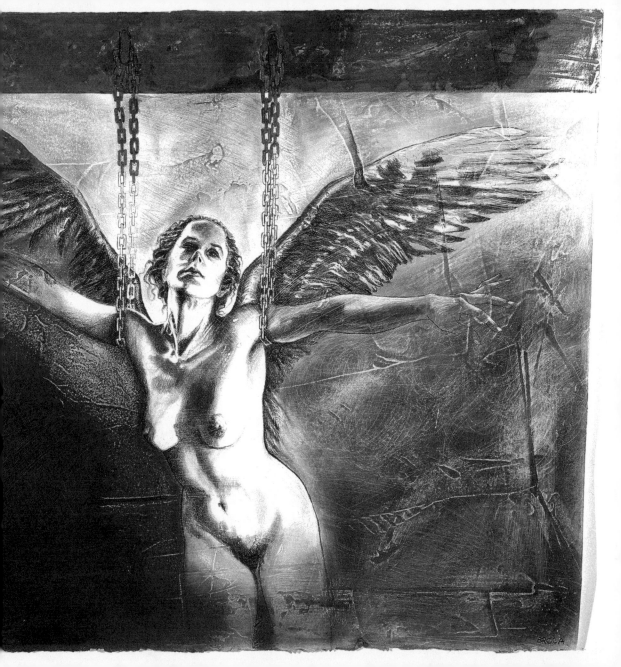

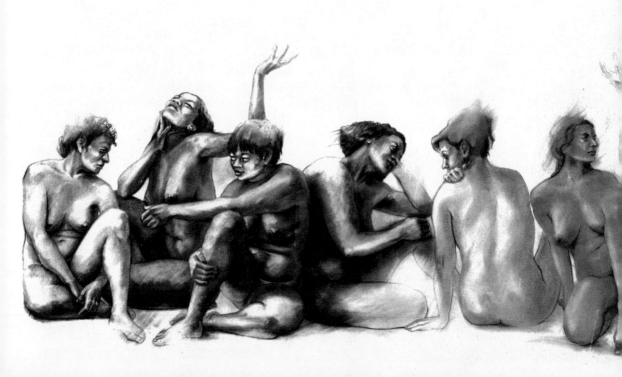

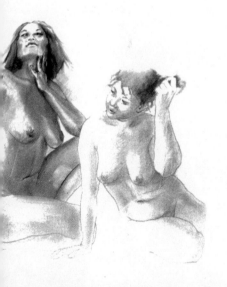

Dark as early dawn
She flies into the day
Out of magma and ash
Out of the furnace within her soul
Onto the soil of freedom.
Here she sings the song of scarlet,
Pastel pink and vermilion,
Sunset mauve and rouge,
And all the shadings of the heart.
She sings the colours of love
As she once danced them
Along the happy arc of the rainbow

Now in the oldest night
Love wraps her round
And carries her on the wind
To the shores of the red Red Sea

And there beyond Eden
She with the Creator, creates
Names, re-names
Shapes and re-shapes
The warp and the woof
And the nature of flight

She who has discovered
The genesis of wings
Is made the mother
Of those who leap over edges
All who fly against the gravitational pull
Of comfort, convention and the established ways
All who hold fast
To the dream of liberty

For she who is not
The servant of man
Remains steadfastly
The servant of Love

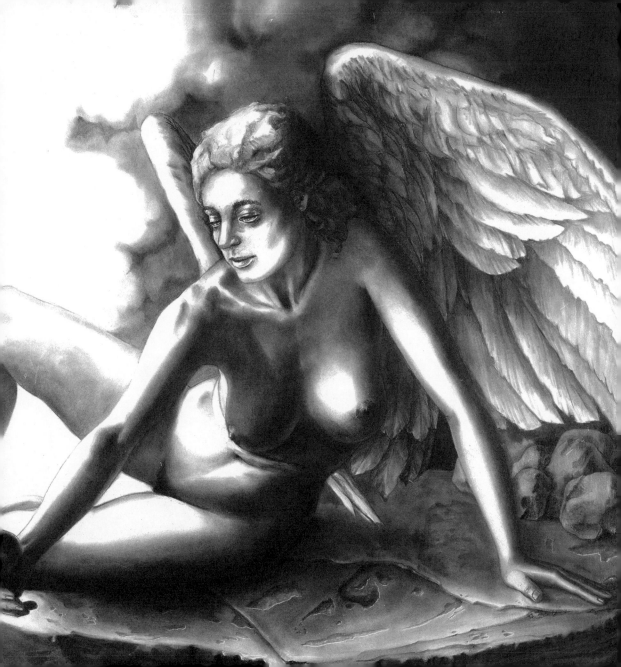

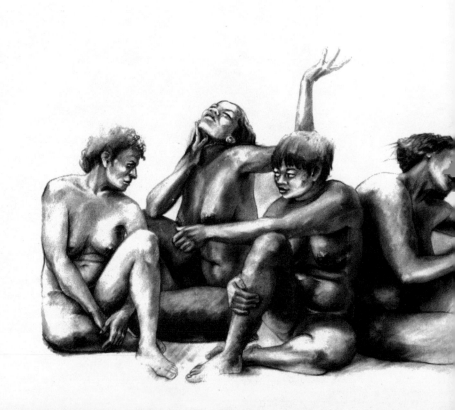

IV

The Chattering Light

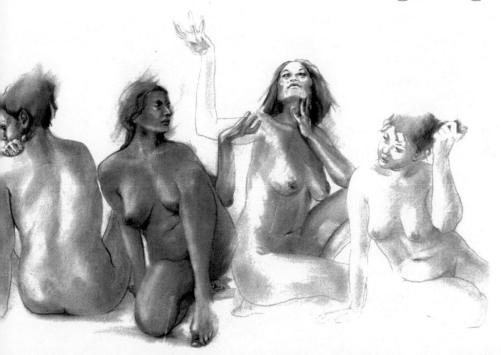

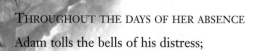

THROUGHOUT THE DAYS OF HER ABSENCE
Adam tolls the bells of his distress;
Adam the dominator
Cries aloud as one bereaved
And his loins long for Lilith
Mate of his morning

His story has it
That Lilith is the abandoner —
He, the first to abandon her,
Declares himself the wounded one

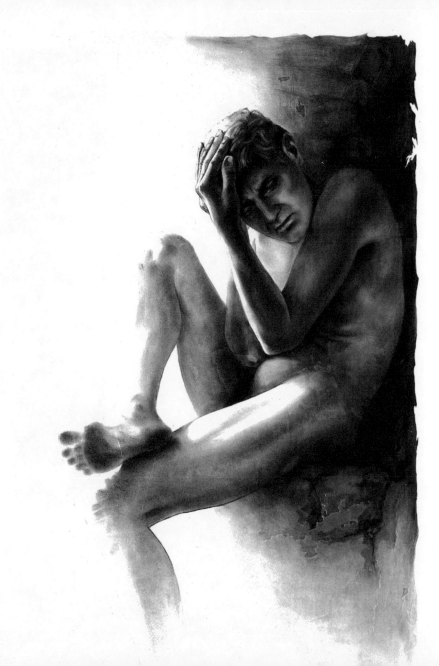

And down through the mythmaking days,

Woman, though stoned, though burnt alive

On pyres of dead men

As witches at the stake

As daughters of fire flung to ash —

Though infant girls are bound, hobbled

Denied the locomotion of their limbs

And mutilated into obedience —

Still Lilith's own song

Whispers from corners of endless rooms

Oozes through walls of prison cells.

By night and by century and by language

Lilith's story stays alive in the hearts of womankind

And falls like dewlight in the dark,

While Adam, alone and bereft

Remains unrepentant still

And cries to heaven or hell —

Who can tell? —

Cries in his bewilderment

For the return of his lost love

And lo!

Across the reaches of the universe

At the speed of dark light

Come three figures —

Angels? Demons? —

Whispering across the coarse desert sand

Drifting now more stealthily

And chanting as they approach:

"Lilith Lilith, you have erred in your ways,

You have followed the devices and desires of your own heart,

You have offended against the holy laws."

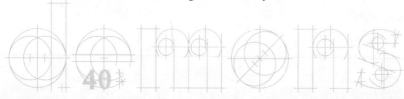

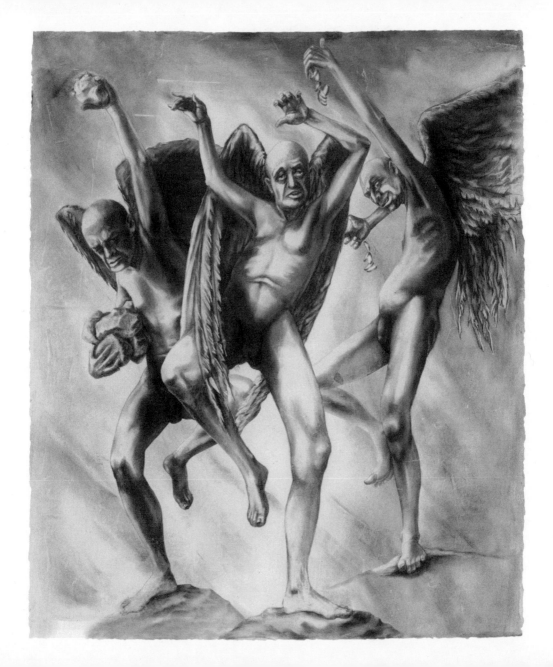

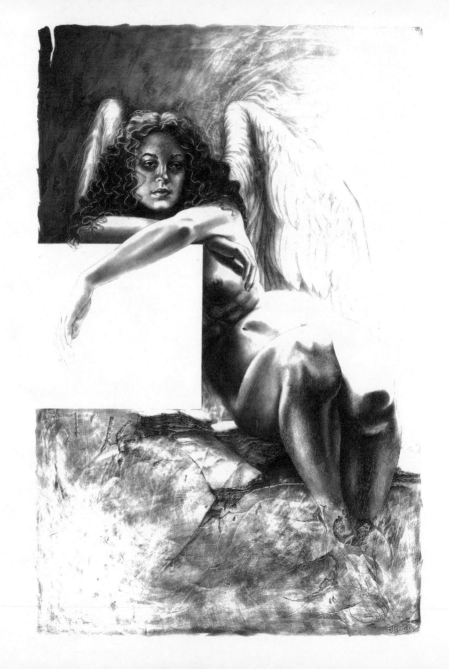

Lilith listens to the skittering sound
Calling her back
To a safe enslavement
Under Adam's rod,
To obedience and security,
To a day-by-day cyclone of domesticity,
To the ritual dance and the steady incantation
Of the wifely role
As woman of silence
Bound to the daily act of nurturance,
To be praised for small sacrifices
And a pleasant visage

Now comes the first figure

Its arms filled with desert stones:

"Come, Lilith, you are the breadmaker.

Turn these hard rocks, your stony anger,

Into bread, into selflessness and nourishment,

Food for Adam's strength;

Make your ambition his well-being;

Offer yourself to him as dainty, childlike,

And fulfill your calling

As woman and subordinate.

For such is nature's way —

Man by design is dominant."

"By this," replies Lilith, "I know
You are no friend of humanity.
Love's food is not the stone of servitude
But the bread of freedom
And the milk of mutuality.
Woman does not live
Solely to feed her family
But to walk in ways of justice
And out of bondage
To the place of promise
Where there is milk and honey for all.
You would turn bread to stone,
Transforming the dance
Into the ossified life
Of the mindless Stepford wife
In an endless and infernal Pleasantville.
If Nature, as you say, decrees
That woman be subsumed,
Then Nature is no friend to me."

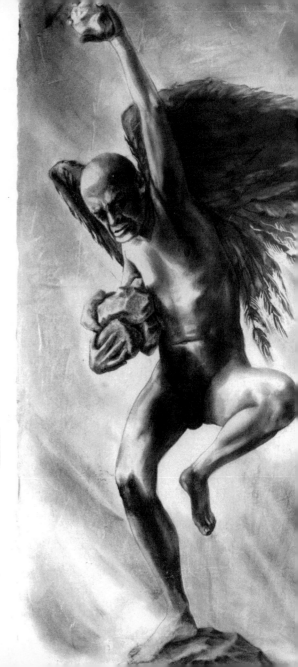

The second tempter leaps forward,

Nodding eagerly. "Ah Lilith,

You are right to be the winged

And wonderful creature that you are,

Shining and proud on the highest mountaintop,

Here to display to all your special powers.

From these lofty heights,

With your wide and outstretched wings

Fall, I dare you — plunge down

To the rock of Adam's bed

And you will not be harmed.

Neither depression nor distress

Assails the well-kept woman."

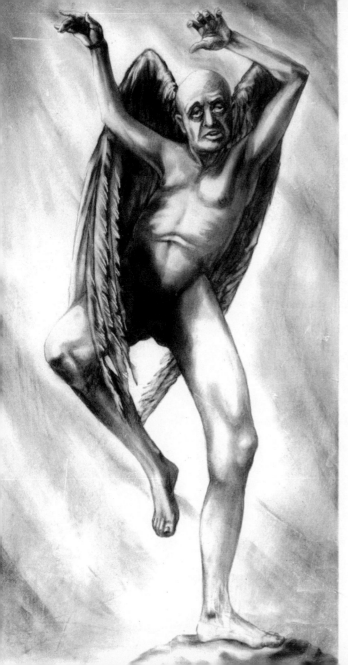

Lilith replies:
"Tempt me not to drop
Into the deep sleep of infancy
Into the slumber of the dreamless life —
The false innocence and chemical serenity
That make of woman a co-conspirator
In man's domain.
My wings were made for flight
And not for falling
Into the hard embrace of prison bars;
My identity is secure
And needs no testing."

Then speaks the third demon,
Gaunt as death, eyes glittering with gold:
"Lilith, you are indeed
Not meant for kitchen alone
Nor for bed of Adam's stone;
From your throne you view
The whole of earth's domain.
You are the chosen of the Highest One
And all, all is yours, the desires of all your days,
If you but bow to Mammon's might
If you but sing Its truth
And call Its name
If you believe and confess the faith
Held in every corner and marketplace
That Money is everything.

Health, security, fame
The adulation of the world —
All are yours.
With money you feed the hungry
Clothe the naked,
For money is earth's ultimate measure
Of all that matters.
With money you pollute the lakes
And with money you clean them up;
You kill and you create.
Power beyond measure is mine to grant
For in my hands lies unlimited abundance.
Stand with me and be
The saviour of humanity;
Just say the words
So simple and so plain
So obvious and undeniable
And it is done:
'Money is God;
Money, Money is Everything.'"

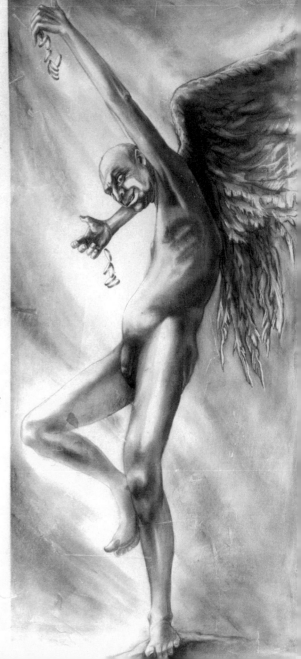

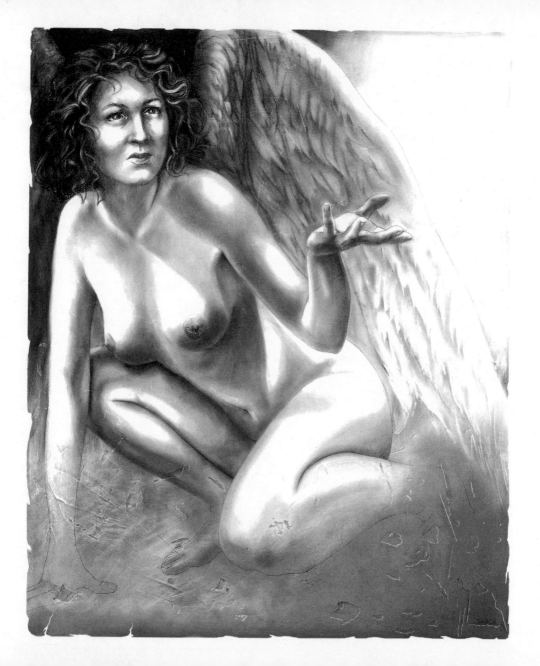

Lilith laughs

"What a cunning sound

In the chattering light of mangled truths —

How you rave in the glitter

Of the Prince of Morning.

Have you not heard, oh Demon,

That you cannot serve

Both Love and Money?

And do you not know

That Love

Is All?"

With these plain words
The demons rage,
Leaping upon her
In their fury:

"Lilith,
You have failed the test.
From this hour
You and every powerful woman
Are bound and relegated
To the region beyond memory
To the land of legend
Where at the whim of mythmaking man
You are transformed into the needful
Demon of the race.
Henceforth you will be cast out
From all respectable company
With prayer and incantation;
Onto the canvas of your flesh
Will be extruded all the excremental visions
Of man's imagination —
Lilith the viper, the scorpion, the black-widow spider

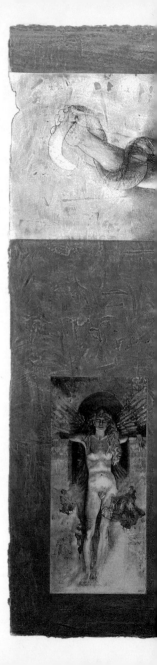

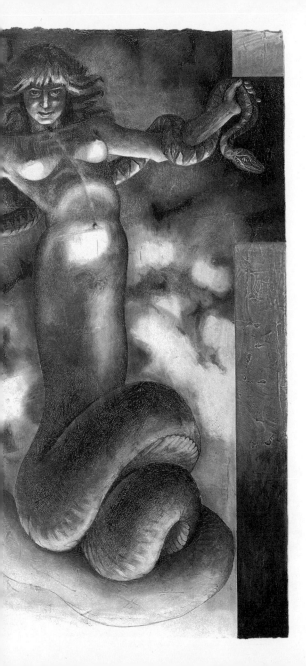

The entirely Other.
How unhappy, Lilith, your sojourn
And your assignation —
Lilith as disease, to be henceforth
Afflicted with the face of evil."

So saying, the three twirl eerily
And disappear, calling as they go,
"Farewell then, Lilith,
We leave you now to your torment.
We go to attend the birthing
Of a more compliant creature."

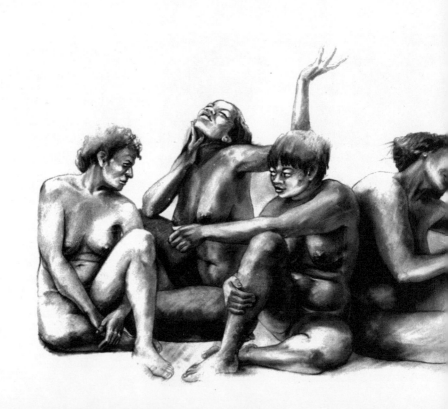

V

Woman Born of Man

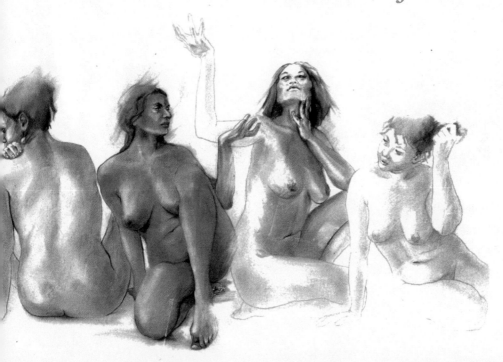

UP FROM ADAM'S SLEEPING SIDE

Into a new and plaintive song

Swims Eve:

Woman born of man

Conceived in his image

Child of his cartilage

Bone of his bone

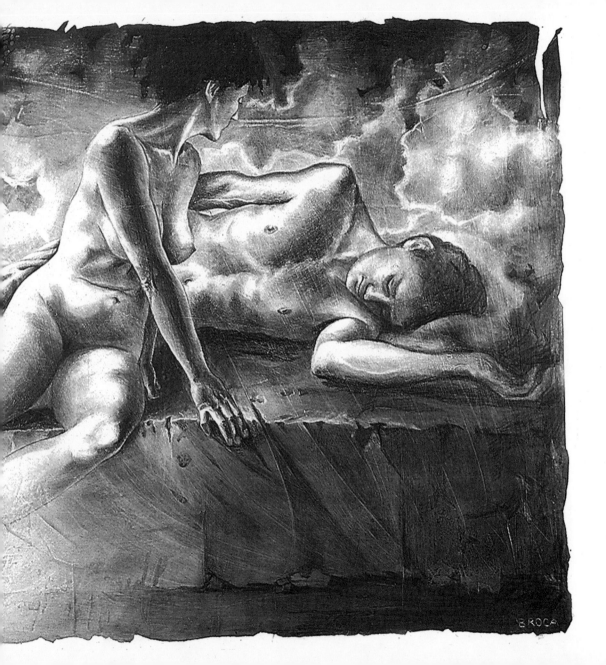

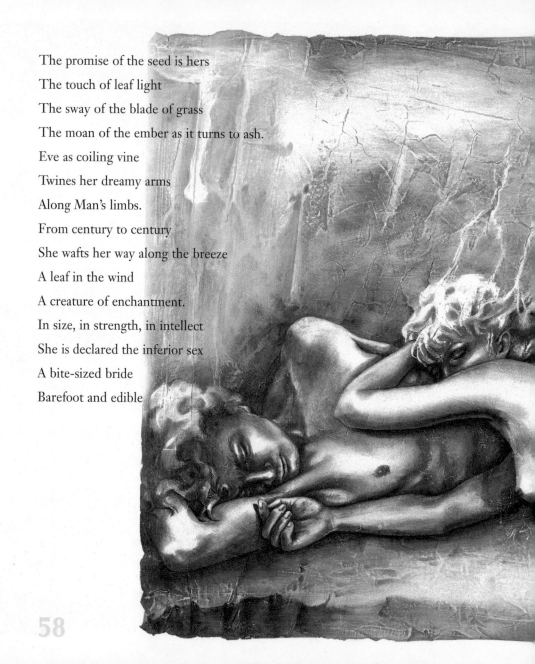

The promise of the seed is hers
The touch of leaf light
The sway of the blade of grass
The moan of the ember as it turns to ash.
Eve as coiling vine
Twines her dreamy arms
Along Man's limbs.
From century to century
She wafts her way along the breeze
A leaf in the wind
A creature of enchantment.
In size, in strength, in intellect
She is declared the inferior sex
A bite-sized bride
Barefoot and edible

58

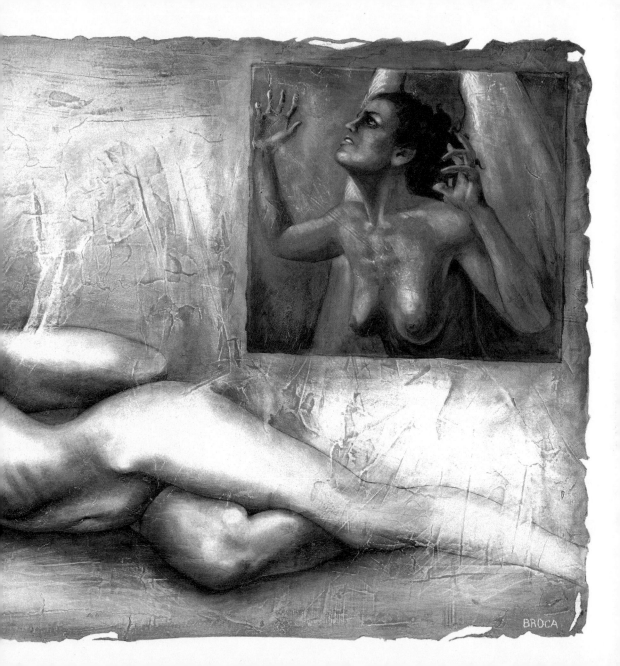

The dream of Eve
Is a dream of dreaming;
Still as a newborn fawn
She rests, perpetually waiting
To waken — a sleeping beauty
Dependent forever
On the kiss of a prince
A narcoleptic ideal.
Eve as chrysalis
Keeps the faith of quietude
And in her winglessness
Wisdom lies bound

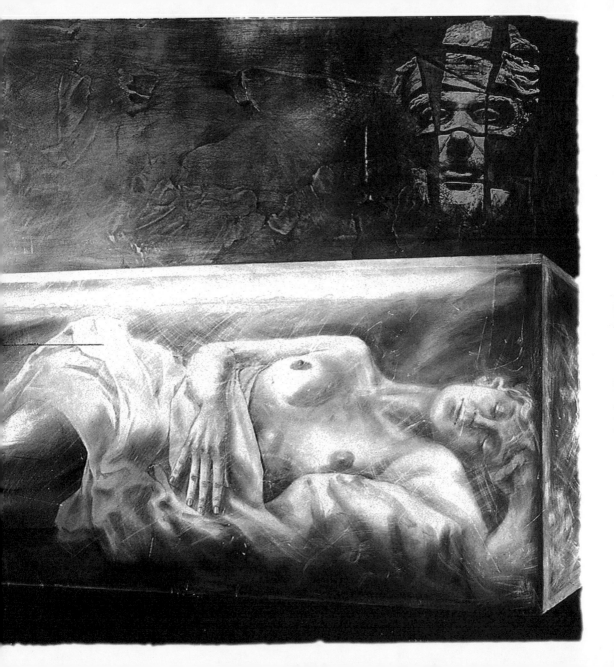

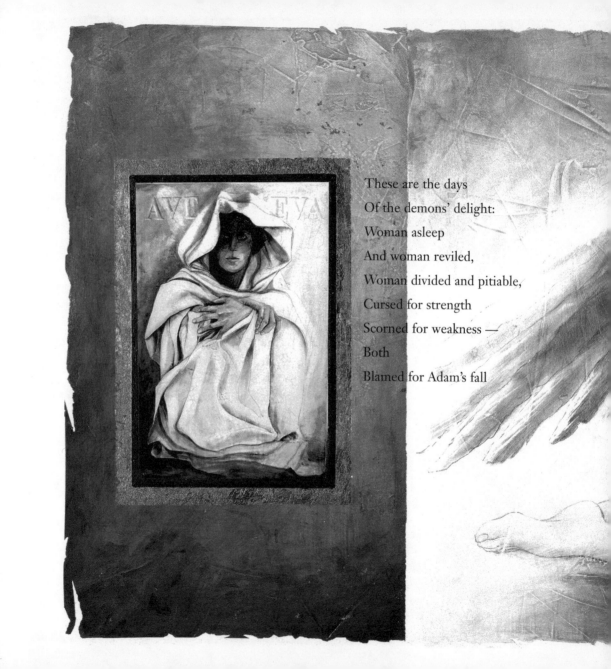

These are the days
Of the demons' delight:
Woman asleep
And woman reviled,
Woman divided and pitiable,
Cursed for strength
Scorned for weakness —
Both
Blamed for Adam's fall

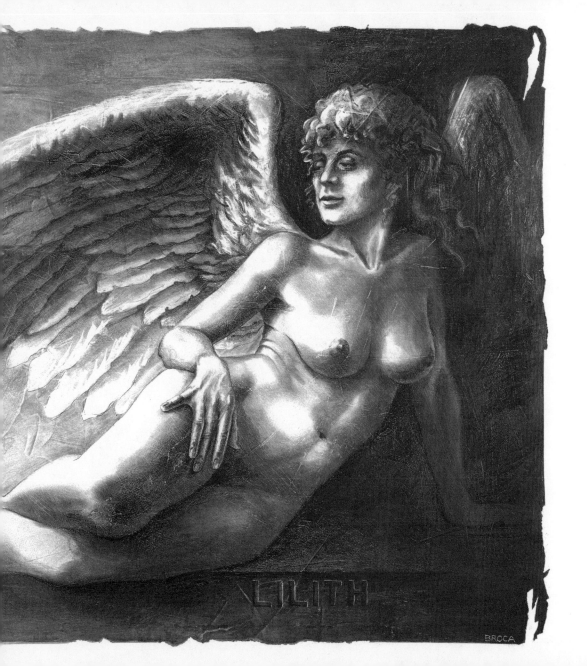

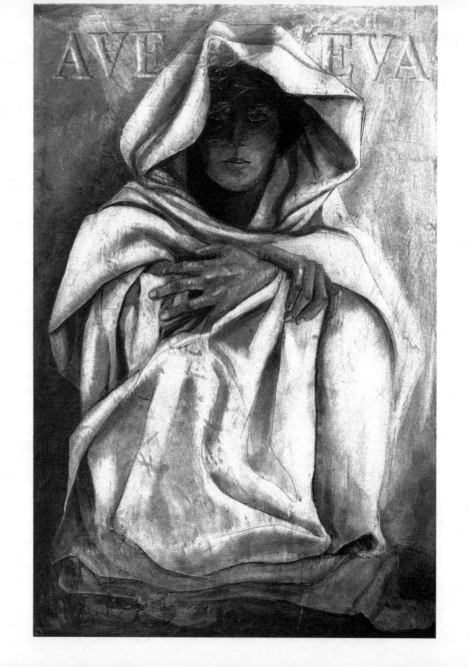

Ah Eve, Eva, Ave Maria
Madonna of the ages
Mother of the world
With head covered in shawls
Face covered in veils
Forgoing all public life
Sleepwalking in the towns
In the forests and the towers
Enduring the days of humiliation
Under the long reign
Of the brotherhood of man

Throughout the leering night
She cradles her whimpering children
Hiding them, chiding them.
"Hush hush, my babies," she croons. "What is that sound?
Is it a kitten scratching on the floor?
A tree branch against the roof?
A rat scuttling along the eaves?
It is the wind of Lilith
Weeping down the chimney
Rattling the loose bricks;
It is the hiss of hunger in the night —
Lilith alone in the red raging banishment
Lilith adrift,
A message in a bottle
Drowning in herself."

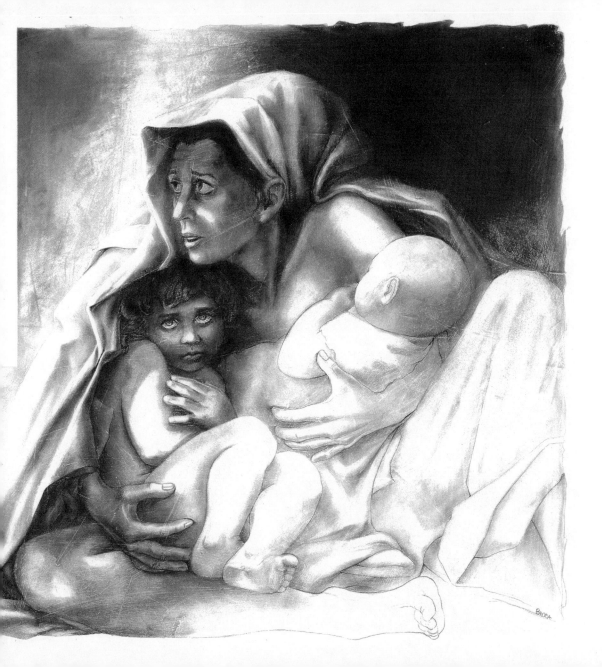

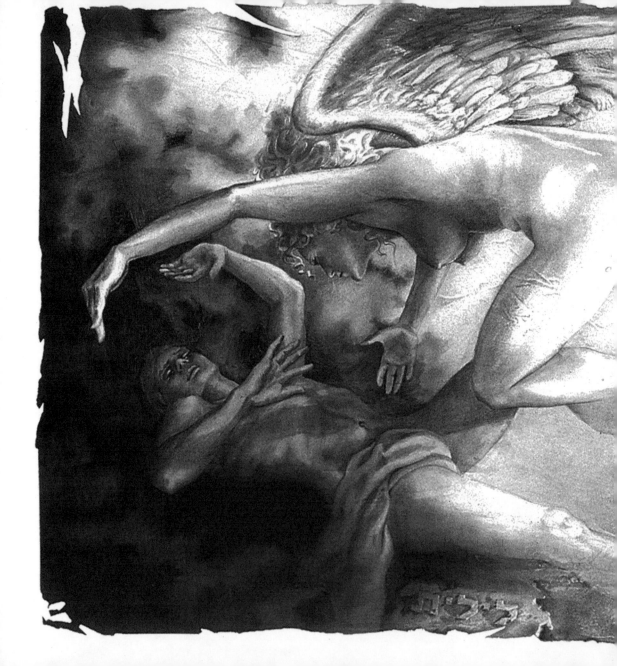

Eve writhes as she moans
And cries to the skies:
"Ah Lilith, my sister, my ocean of distress,
You siren of seaweed arms,
You swoop upon young men sleeping alone
And cling —
A vampire, a vulture
A voluptuous devil
Sucking the life force and the lifeblood
From the virginal night.
You devour all that is small and weak
Vulnerable and fragile.
Beware my daughters, my sons,
My darling ones,
Lest you be lured
By Lilith to her lair."

By such wailings
Lilith is demonized
While the three fiendish denizens
Goad the whole world to acknowledge
That Mammon, after all, is God —
That man is made for money,
Just as woman is made for man.
And from midnight to midnight,
Gloria to the Great God Mammon
Ascends from every barren corner of the globe,
From television sets and websites.

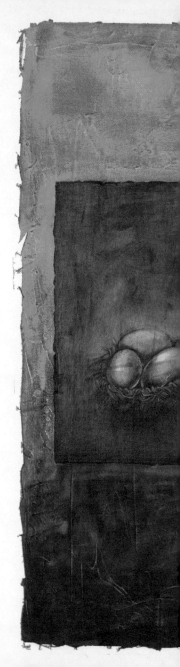

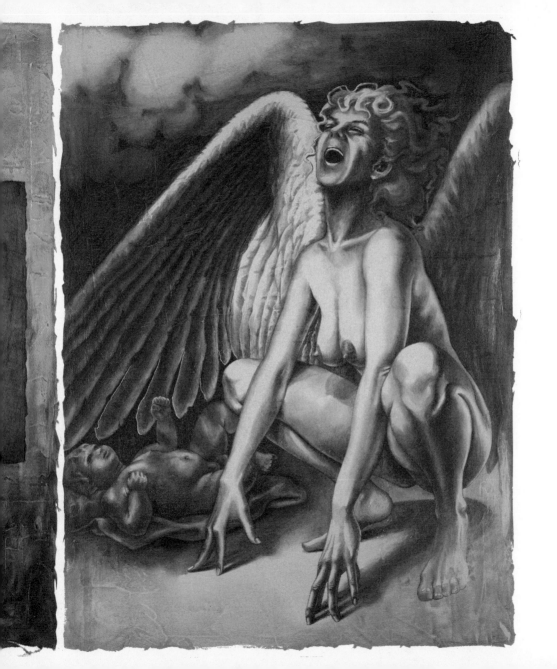

And in the hour of Eve asleep
Mammon the Almighty Consumer
Rumbles forth to ravage the earth,
Jaws yawning. It launches its feast
By nibbling eyes and all things small
All things bright and beautiful
Butterflies, tadpoles, songbirds
The flutterers, the sliders
The crawlers, the walkers
The babies in the third world
The grannies in the cold world
The sitters on street corners
The Mom and Pop shops
All, all are devoured
In Mammon's great feast.

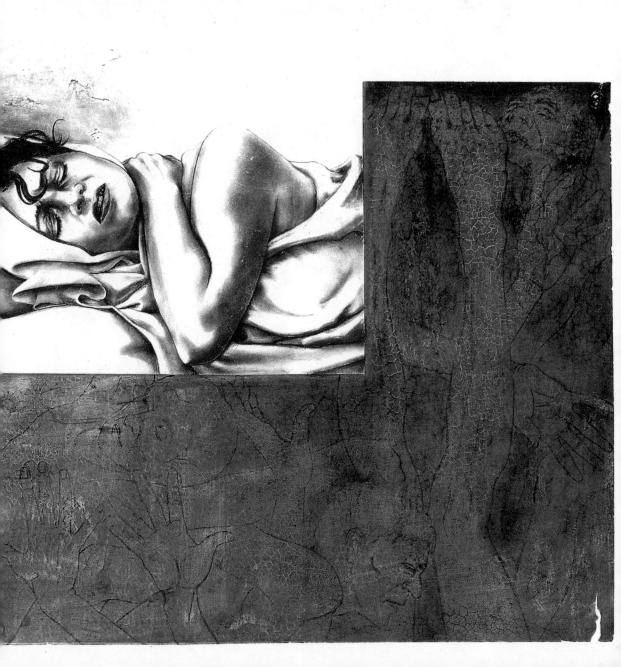

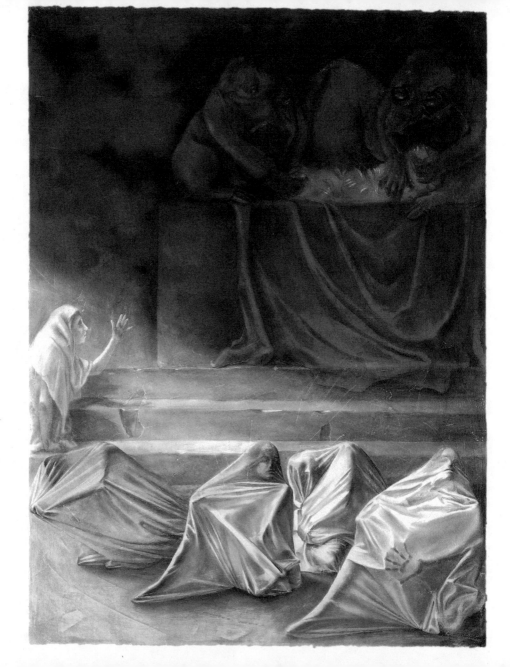

And Mammon's corporate marketeers,

The gaunt and hollowed hunger-makers

"Whose god is their belly,"

Leap like plagues of locusts

Hobbling the inhabitants of earth.

Each in their turn become creatures

Who dance without feet

In the frenzy and heat of consumption

As they chant their creed in unison,

"Money, Money is Everything,

Money is God,"

And all earth bows down to worship It,

For the power of Love lies broken

In the dust

Howl howl,

Sweet daughters of Eve —
Howl for the sons
Mangled in the machinations of war;
Howl for the mothers, the babies
In the midst of famine
Languishing while the ones
They love more than life
Lie dying in the drought;
Cry for the daughters of Lilith
The countless strong women of the ages
Feared for their power
Condemned for their passion
Uprooted from their potential and relegated
To the empty pages of their unlived lives;

Weep for old men, old women,
Adrift on the streets
In rags against the moon,
The crones, the hags on broomsticks
Sailing the long long night
Flying in futility
The children lost

For these are the days
Of the demons at play
Roaring across the skies
Over the plains and in the hills
Gleeing in their unbridled greed
While they pillage the planet

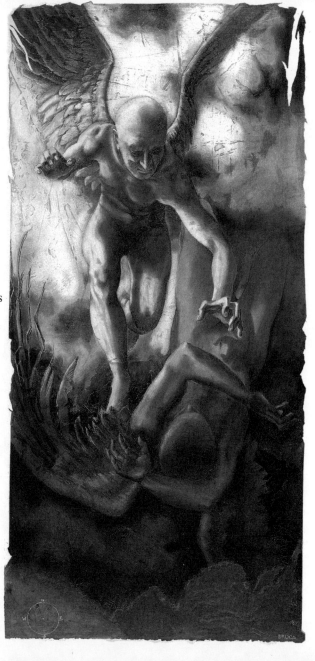

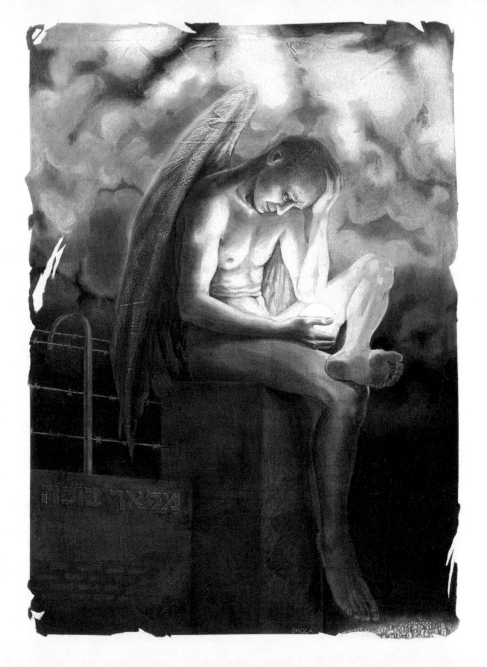

How pitiable the people of earth:
Eve against Lilith
Man against man
And Adam listless, Adam wild
Pining still
For his first love lost

Lost as well
Are the minions of Mammon —
Hearts turned to ash
Blood turned to rust.
Almighty man
Lies chastened at last
With only his rib
As soul-mate and comfort,
Only his echo
In her hand-me-down skin.
How infinitely lonely,
Adam and Eve,
These lopsided lovers

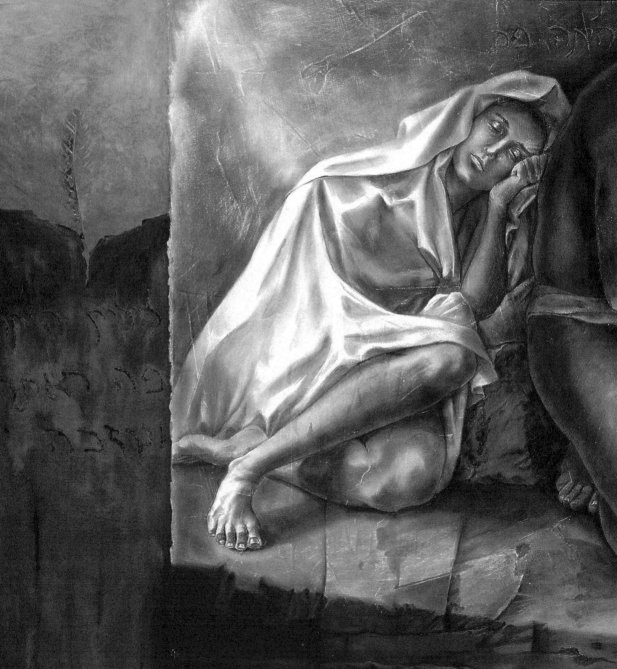

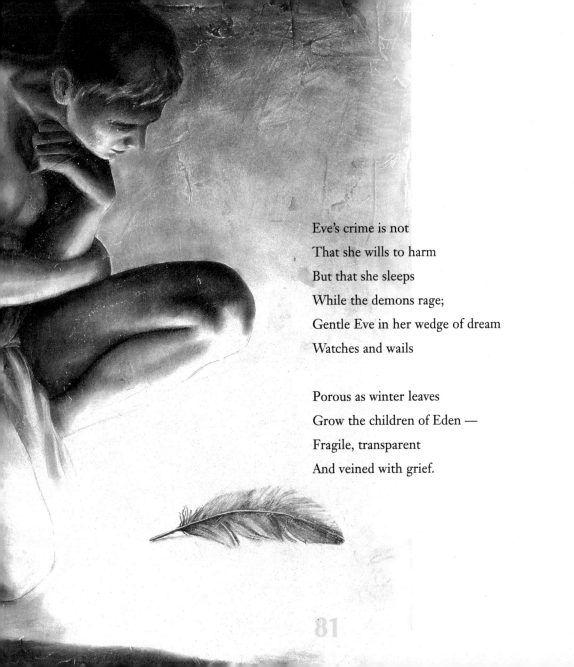

Eve's crime is not
That she wills to harm
But that she sleeps
While the demons rage;
Gentle Eve in her wedge of dream
Watches and wails

Porous as winter leaves
Grow the children of Eden —
Fragile, transparent
And veined with grief.

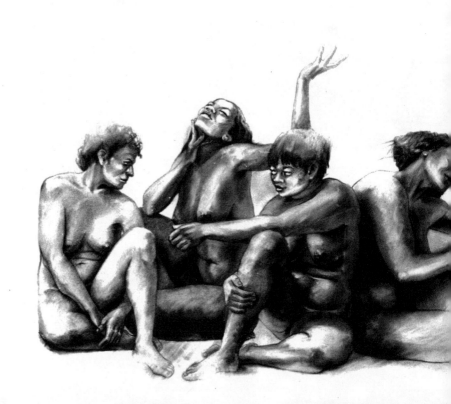

VI

The Servant of Love

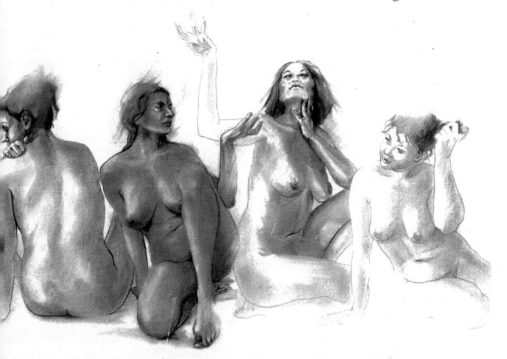

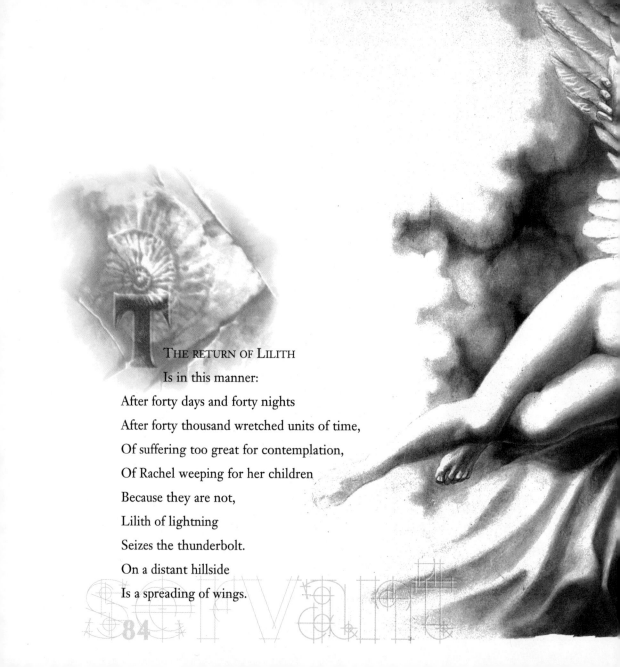

THE RETURN OF LILITH

Is in this manner:

After forty days and forty nights

After forty thousand wretched units of time,

Of suffering too great for contemplation,

Of Rachel weeping for her children

Because they are not,

Lilith of lightning

Seizes the thunderbolt.

On a distant hillside

Is a spreading of wings.

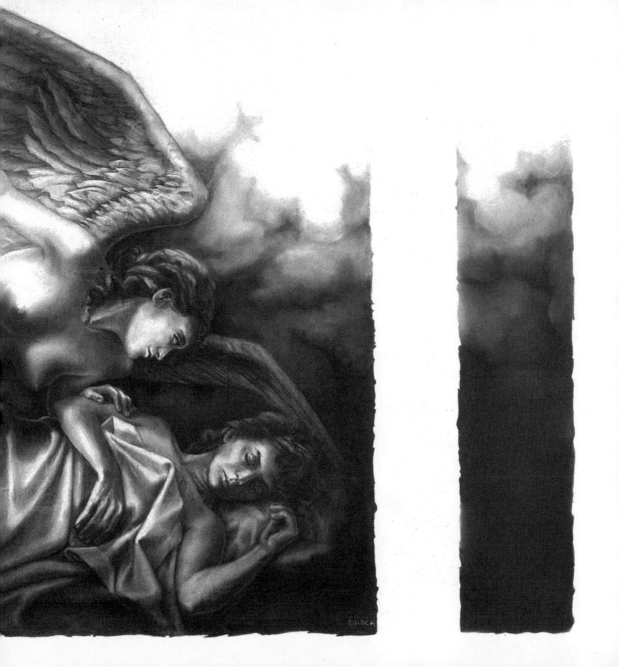

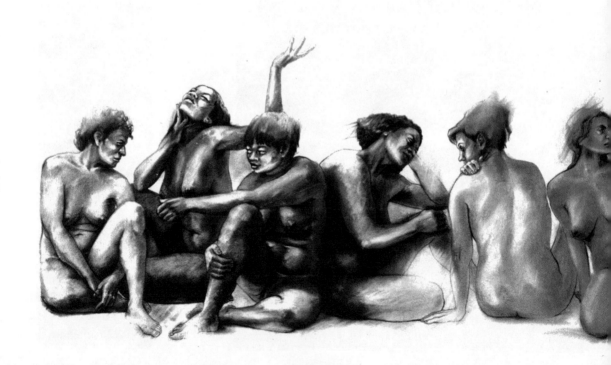

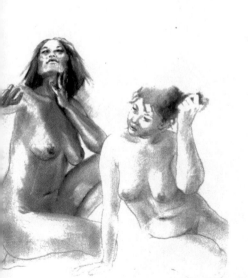

From out of the land of legend
Into the orb of our day
She comes singing us to the place
Of beginnings

The whispering sound of the underground stream
Spirals its way along
The cavernous coils of history;
Through the emptied hallways of time past
She swims her way up
Through a shroud of shards —
Into the corridors of daylight,
Her body wet and bleeding

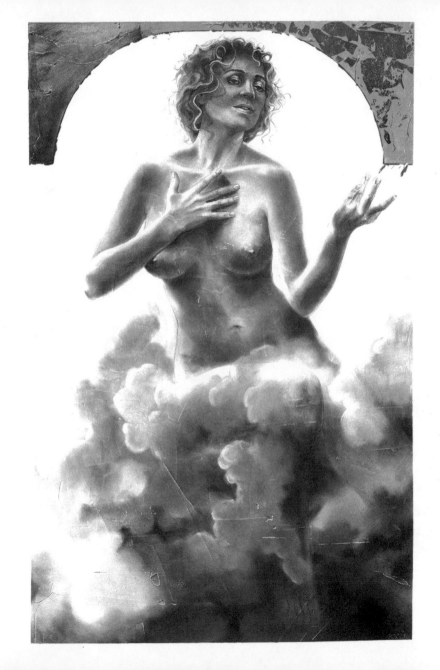

Lilith

Long and wailing ululation
Earth's first and elemental woman
Formed in the mystical morning
Of dust and dream
And born today of fire and tears

Lilith

Of mist and deep mourning
Raincloud, hail
And storm made animate
Blood and bone

The status of her re-birth is this:
Flower and stone and star
In a garden beyond gardens
In a time of tides and human tragedy
Lilith and Eve
Eve and Lilith
Two weeping as one
And sung to new song
By the Holy One who does no wrong

This again is the hour
Where loss is transformed
By Love's design —
For the longing with which Woman longs
Is Love's longing that persists through us.
And in the tomb of our utmost emptiness
Dwells the Great Surprise:

"Woman, why weepest thou?
Whom seekest thou?"

Breath
Prayer
Salutation

Constant as a heartbeat
The aching Presence
Steps through the walls
Of the porous universe.

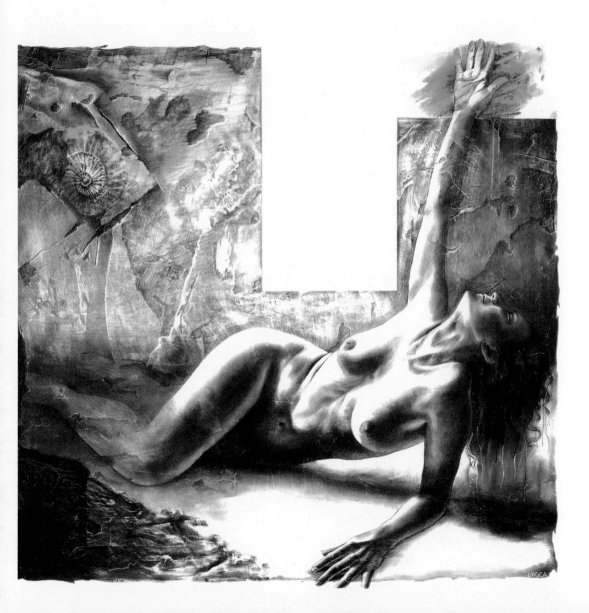

A leaping of light —
A word, a name —

"Lilith"
And up from the battered seed,
Wings loud with exultation,
Comes Lilith, at last —
By plane, by foot
By taxi, by wheelchair
With shoes, without shoes
From the back alleys and the bedrooms
From cardboard boxes

Sudden as thought
In a hovering of wings —

Woman alive

Incandescent
Merging the stars
Shouting the light

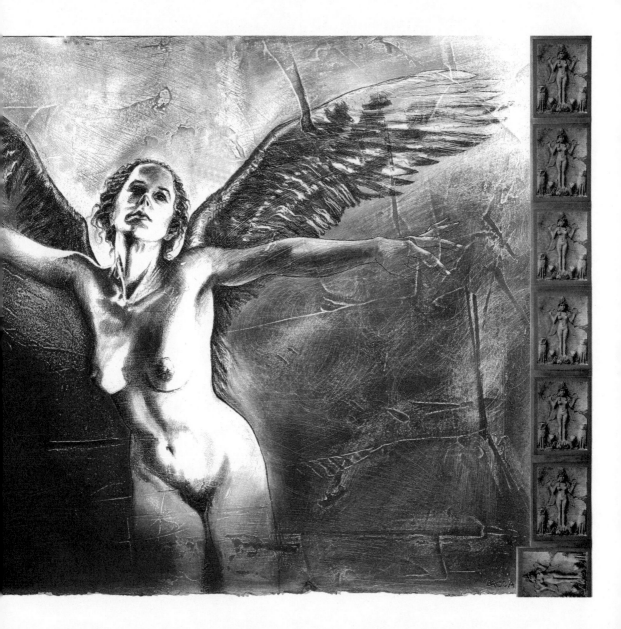

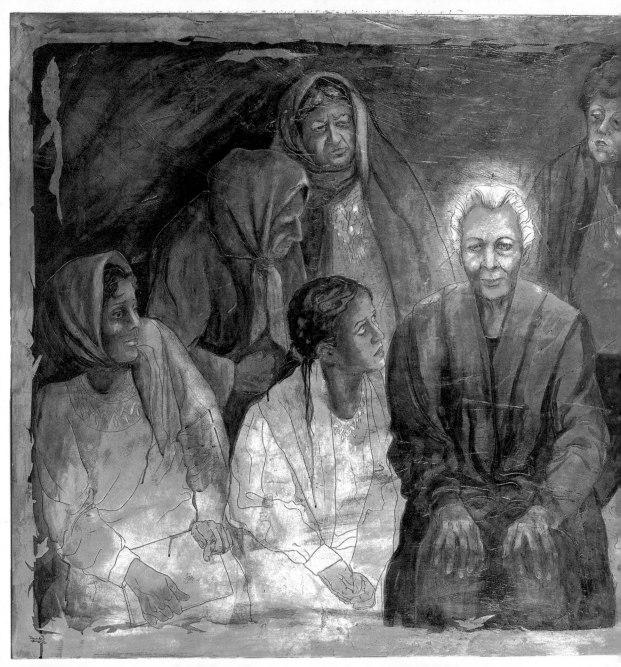

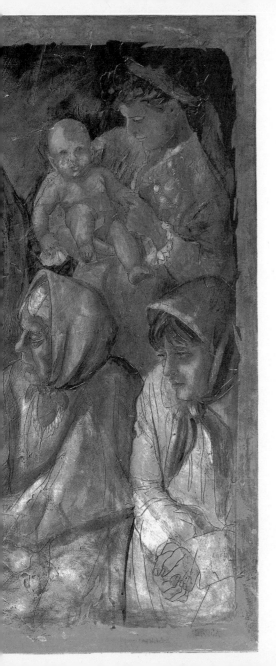

"Sisters, Mothers, Grandmothers,
Daughters of creation,
Now as the days of paternity wane
So too the age of our compliant ways.
In the dawning of the sisterhood
It is we who must waken and fly
To the Plains of Abraham
To the boardrooms of the mighty
To the gatherings of the clans
And to all public battlefields,
There to shine our full humanity
Through the looking-glass.
For we who are the vilified
And made wholly other
Know that otherness is banished
By otherness embraced

My sisters, the task is therefore ours

To make a stronger design

To knit each tale of grief

In the name of the child

Along the quivering edges of our wings

And to birth the new age

Under the banner

Of our true and original name

For we are women —

Whole and equal

Strong and beautiful

Gentle, free and wise.

Let us now therefore walk boldly

Out of the whirlwind of unspeakable memories

Into the mighty rivers

Of truth telling

There to proclaim in thunderous praise

Freedom's ways

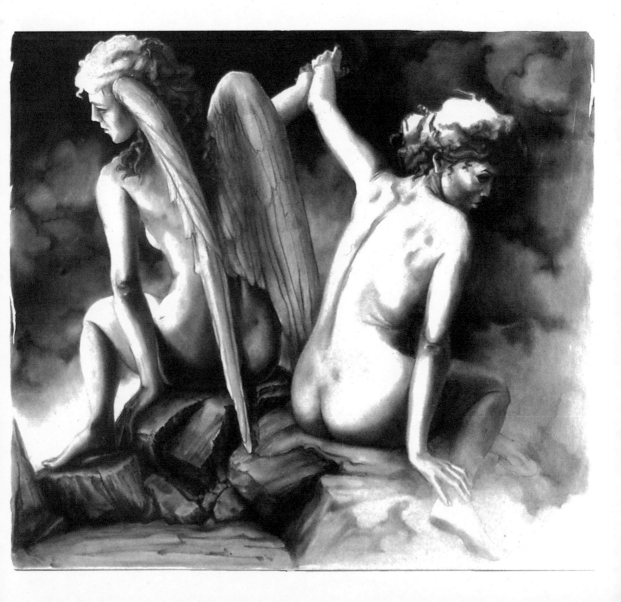

Justice

Mutuality

Magnanimity

We have lived the terrible evidence

Yet through the winged ways of trust

Through truth and reconciliation

We shall come once again to know

That the Ground of our Being is good.

From this Ground we are formed,

On this Ground we live,

And to this good Ground we go,

Not as departure

But as homecoming.

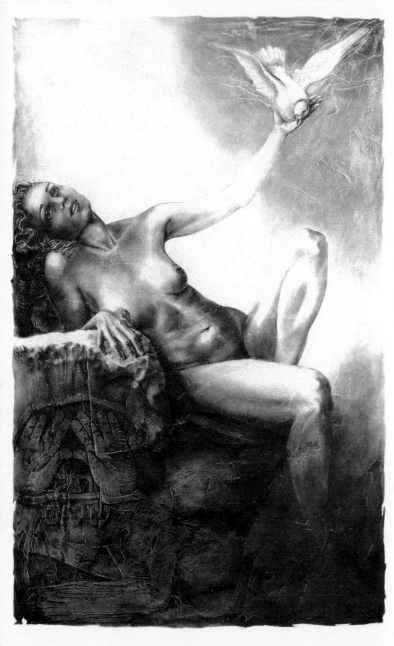

For Love is the element
In which we swim;
Love is our going forth
Our coming home
And our transforming hour

This, the music
That I, Lilith, hear
And Holy is the Singer
I heed.
Blessed be."

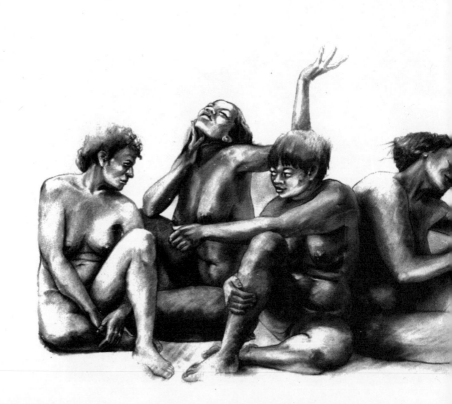

VII

Coda

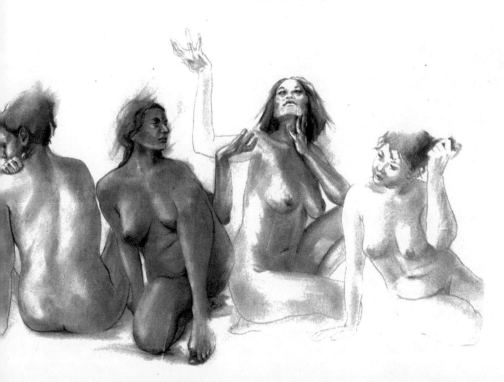

After
The victory,
Afterwards

Comes community —

Sisters, brothers,

Friends, lovers

Glistening with a growing gladness

So light and bubbling it rests

Like the morning or evening sunlight on her naked arm,

Cool, bright, happy

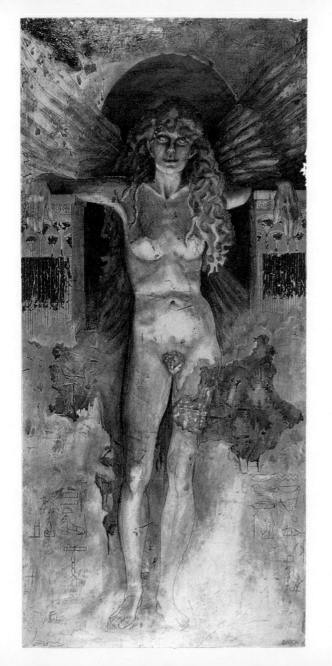

What endures of Lilith's turbulent tale
Is this:
She has loved life
She has spent her life
She has danced to the ends of her wings
And now what remains
In the gardens of the world
Is the breath of God
Weaving love songs

"Lilith, my brave
My leaping one —
My dancing delight,
My earth, my home."

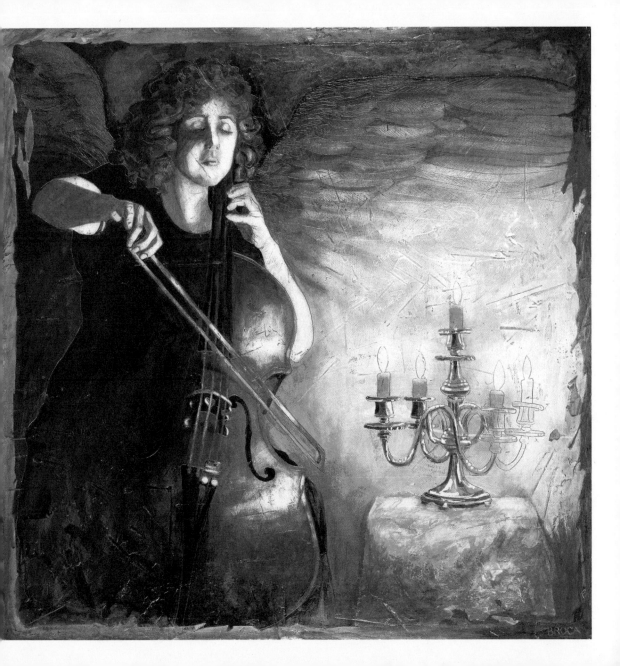

Lilian Broca

Lilian Broca is a noted visual artist who is a graduate of Concordia University and received her Masters in Fine Arts from the Pratt Institute in New York.

She has exhibited widely across North America and her work is included in numerous public and private collections.

Lilian Broca lives in Vancouver, British Columbia.

Joy Kogawa

Joy Kogawa was born in Vancouver, British Columbia. She achieved international prominence with the publication of her novel *Obasan* (Penguin Books), which dealt with the experience of Japanese-Canadians during World War II. For this work, she received numerous awards, including the American Book Award and Best First Novel.

She has also published several books of poetry, fiction for young people, and the novels *Itsuka* and *The Rain Ascends*. Joy Kogawa is a recipient of the Order of Canada.

She lives in Toronto, Ontario, where she writes and is active in community work.

List of Artworks

Page 38: *Shackled 1*, 1994 (graphite, acrylics, spackle, on rag paper, 29" x 22"). Coll: artist.

Page 41: *The Demons' Temptation*, 2000 (graphite, spackle, on rag paper, 30" x 43"). Coll: Mr. David Goodman.

Page 42: *She Lived and Danced to the End of Her Wings*, 1999 (graphite, oil pastel, spackle, on panel, 48" x 32"). Coll: artist.

Page 50: *God is Love*, 2000 (graphite, oil pastels, spackle, on panel, 36" x 30"). Coll: artist.

Page 52: *Lilith the Snake and her Goddess Self*, 1996 (graphite, acrylics, collage, spackle, on rag paper, 33" x 27.25"). Coll: artist.

Page 57: *Lilith Leaving Adam's Bed*, 1996 (graphite, acrylics, spackle, on rag paper, 22.25 x 30"). Coll: artist.

Page 58: *Lilith with Eve and Adam*, 1995 (graphite, acrylics, spackle, on rag paper, 24" x 43"). Coll: artist.

Page 61: *Eve as Chrysalis, Dependent Forever on the Kiss of a Prince*, 1999 (graphite, acrylics, spackle, on rag paper, 32" x 43"). Coll: artist

Page 63: *Lilith and Eve*, 1996 (graphite, acrylics, collage, spackle, on rag paper, 22.25" x 42.75"). Coll: artist.

Page 64: *Eve*, 1999 (acrylics, spackle, on panel, 36" x 24"). Coll: The Vancouver Jewish Community Centre.

Page 67: *Hush, Hush, My Babies, What is That Sound?*, 2000 (graphite, pastels, spackle, on rag paper, 30" x 42"). Coll: artist.

Page 68: *An Encounter with Lilith*, 1994 (graphite, collage, spackle, on rag paper, 21" x 29"). Coll: The Vancouver Art Gallery.

Page 71: *Lilith with Baby and Nest*,1995 (graphite, acrylics, spackle, on rag paper, 30" x 36.5"). Coll: artist.

Page 73: *Eve Trapped in Edge of Dream*, 2000 (graphite, acrylics, spackle, on panel, 32" x 48"). Coll: artist.

Page 74: *Mammon's Minions*, 1999 (graphite, spackle, on rag paper, 43" x 32"). Coll: Mr.R.Colby.

Page 77: *Sons of Light & Sons of Darkness*, 1994 (graphite, acrylics, spackle, on rag paper, 42.5" x 21").
Coll: Dr.Yosef Wosk

Page 78: *Weeping Angel*, 1994 (graphite, spackle, on rag paper, 29" x 21"). Coll: artist.

Page 81: *Adam Alone with his Rib as his Shadowy Companion*, 2000 (graphite, acrylics, spackle, on rag paper, 32" x 52").
Coll: artist.

Page 85: *From the Land of the Legend She Comes Singing Us to the Place of Beginning* 1999 (graphite, spackle, on panel, 32" x 48"). Coll: artist.

Page 88: *Dark As Early Dawn She Flies Into The Day*, 2000 (graphite, pastels, gold leaf, spackle, on rag paper, 38.5" x 25"). Coll: artist.

Page 94: *A Prophet*, 1993 (acrylics, spackle on panel, 48" x 72"). Coll: artist.

Page 97: *Lilith and Woman*, 1999 (graphite, spackle, on panel, 36" x 40"). Coll: artist.

Page 98: *Tel Shalom*, 1999 (graphite, acrylics, spackle on panel, 50" x 36"). Coll: Dr.& Mrs. Leonard Comess.

Page 103: *Lilith*, 1993 acrylics, spackle, on panel, 78" x 36"). Coll: Ms. Letia Richardson

Page 105: *The Seventh Muse*, 1993 (acrylics, spackle, on panel, 48" x 48").
Coll: Ms. Kristine Bogyo & Mr. Anton Kuerti.